METAL JEWELRY

By
J. PELLE and F. MAISON

Illustrations
by
Marc BERTHIER

DRAKE PUBLISHERS INC. NEW YORK

ISBN 0-87749-464-9
LCCC N 73-3718
Published in 1973 by
Drake Publishers Inc
381 Park Avenue South
New York, N.Y. 10016

Jewelry...: has the word ever failed to excite people ?

Jewels are universal objects most familiar to all human beings. They have come to us through the ages as symbols of both beauty and wealth. And while it is possible to trace the history of a certain jewel (as well as date the discovery of the metals used in its crafting), it is quite impossible to separate the history of jewelry from that of humanity.

Whether used as ornaments, good luck charms or for magical purposes, jewels have always been a part of all cultures, and in all places.

For a long time, at least in our part of the world, the term "jewel" was synonymous with precious (and thus costly) objects. Then came costume jewelry, which, at reasonable prices and available to all, could be made to suit all kinds of fashions.

Very recently, another change has taken place: from a more or less industrialized stage, the making of many types of jewelry has become more individualized, and methods such as enameling, and one which we intend to study in this work-metal jewelry have become popular. This has been made possible by the improvement of certain techniques (baking of enamel) and the wide commercialization of materials.

Then also, there are to-day fashions, which tend towards fancifulness and originality. Thus, even though the art of jewelry-making still holds its letters of nobility, another art has developed alongside with it, one for which imagination and originality are most appreciated.

This short work has been designed to help you become your own jeweler. It means to guide your first creations, to suggest a few ideas, and above all to teach you simple and useful techniques, requiring few tools for the crafting of metal.

Once the basic knowledge has been thoroughly mastered, you will able to use your imagination as freely as you want. You will be free to create your own shapes and mixing

INTRODUCTION

various, materials: wood and metal, metal and pearl beads, metal and leather, stone and metal, together with many others you will discover by yourself.

And although jewelry-making is a pleasant hobby for adults, it can also become a gratifying and inspiring activity for teenagers as well as the elderly.

Let us add from experience that contrary to widespread opinion, it will greatly interest boys, metal working appearing to them as a typically masculine task.

Before you begin, let us make a wish that you may have many ideas of your own that will allow you to create an extraordinary line of jewelry.

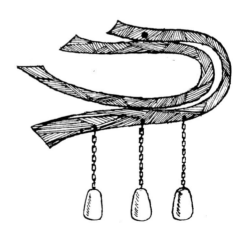

Another example of pendant or lapel ornament

THE
WORKSHOP

Metalworking requires relatively little material. It is an activity which interests young people from about 12 and over.

Girls will be attracted by the jewelry itself.

Boys appreciate the creativity involved in the work. Their physical strength will be put to work, mostly when working on sheet metal and wire.

Apart from the list of tools and materials given in the next chapter, no special installations are necessary in creating a jewelry workshop.

A sufficient number of sturdy tables should be provided so that everyone has enough room to work without getting in one anothers way. One can work either standing or sitting, depending on preference.

A collective workshop should not have more than 15 or so participants, so as to allow for guidance and instruction from the teacher, and, probably, more important, as a control of the deafening noise level! We should observe that if metalworking is a clean hobby, that can be practiced anyplace and without wastes, it is nevertheless a noisy one.

Participants should get used to the noise: forging is not a quiet activity, and ten hammers hitting together make a lot of it. But that's the price we pay for the beauty of the finished object. From experience, we can tell you the noise is well accounted for by the creation.

Neighbors might be disturbed, however, as in school with a workshop operating next to a classroom, and it should be taken into account.

In this respect, metalworking is an ideal outdoor activity, here a log, a step, etc., can be used in place of a table.

Concerning the work itself, the simplest method — which gives the best results too — is to show the participants several already finished examples of jewelry. It is also the best incentive.

The instructor can make a general survey of the various techniques used with sheet metal and wire, and then allow each participant to work by himself. He will then be in a position to help cach student concerning a particular techniques as well as make suggestions about various possibilities.

By using each student's work as a presentation to the class, the instructor will thus be able to make concrete points which will be meaningful to each student. He will also be able to describe the various aspects of metal working in each of their many stages.

MATERIAL AND tools

MATERIAL USED

The objects we introduce in this work are crafted mostly from thin metal.

The easiest metals to work with are nickel silver and copper. They are very malleable and found in sheet or wire.

Not many tools are needed to shape these metals, and if you have ever practiced copper enameling, you already own most of them. Most of those tools can be found in any toolbox at home. Others can easily be made for a small amount of money (which we will see while discussing working methods). The following techniques are applied when working both on copper and nickel silver. (However, let us point out that nickel silver is advisable in the making of jewelry as it is less oxidizable and thus does not need to be varnished in order to protect clothing. Sometimes even the slight oxidation occurring with time gives it a remarkable patina when polished with a natural or synthetic chamois-leather. On the other hand, if a new shine is wanted, nickel silver should be polished with an aluminum pad).

Nickel silver (an alloy of copper, nickel and zinc) is easly found in stores specialized in crafts which sell both sheet and wire in a great variety of gauges.

Note: you should get annealed metal so that it will be wrought more easily. As other metals have their own spring effect and are not liable to keep a determined shape (especially for

larger surfaces or wire over 20 gauge which snaps easily).

On the other hand, for necklaces made from a single 18 or 16 gauge wire, non-annealed metal should be used, because it keeps a certain rigidity (i.e. spring) and will not be deformed easily. In this case, only the ends need to be worked on. This is more difficult than with annealed nickel-silver, but gives better results.

Copper in thin sheets can also be found at craft suppliers. But copper wire for jewelry should be purchased at a metal company, as the one sold at craft stores used for enameling is too thin for jewelry making.

To work on metal, either sheet or wire, a few simple rules must be followed as well as a few particular techniques learned.

A list of the needed tools will be found at the end of the chapter.

The following chapters deal with the working of sheet metal; the techniques used with wire and finally how to make different types of decoration and/or mounting.

Following that, we will study the use of pearl beads and cabochons (glued rounded pearls).

Next you will find the detailed explanations for the making of the models illustrated by the photographs.

These models, we hope, will guide your first creations and then allow you, using the inspiration they may give you, to free your creative imagination — all fancies being welcome in this line of crafts.

TOOLS

The list given here concerns exclusively tools needed for the different techniques shown.

We should point out that in certain cases, depending on the model under study, supplementary tools such as mandrel and gauge etc. will be needed, some having to be purchased others perhaps home made. Details concerning

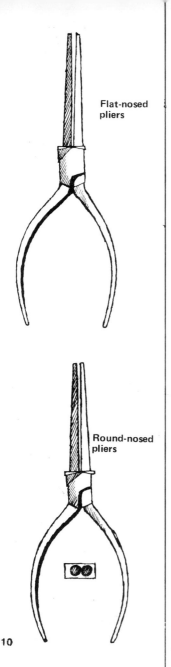

Flat-nosed
pliers

Round-nosed
pliers

these elements will be given along with the techniques.

• A bench-anvil (a small block of cold rolled steel) on which metal will be hammered. It is found in hobby shops and hardware stores, but in order to avoid its purchase any flat-surfaced steel mass will be suitable.

• A small two-beaked anvil, mostly used for the making of rings, purchased from the same supply stores.

• A planishing hammer, for forging: it has two faces to head — one flat, the other slightly bellied.

• A ball-peen hammer.

• Cutting pliers, for cutting and clipping wire.

• A steel ruler (6" long) marked in millimeters and inches.

• A square ruler.

• A needle-point scriber for drawing lines on metal.

• A few pairs of flat- and round-nosed pliers, in any size (large, medium, small). Bag several, of different sizes.

• Several hand- and half-round files, of different grain (including needle files, used in finishing smalland delicate areas).

• A pair of perforating pliers.

• A forming block identical to the one used for enameling. The different faces of the wooden cube are scooped out in a half-sphere of different width and depth, used to shape convex pieces.

In preparing this list, we had in mind an individual working or a small shop with three persons working together at most.

In this case, the amount of tools is sufficient as they can be handed from one to another. If the workshop is to be composed of a greater number of participants, the number of tools will have to be increased, especially with regard to the different types of pliers and most of all the planishing hammer. The ideal would

of course be if each craftsman had at his dispo-
sal such a hammer for his own use.

FINISHING MATERIAL

For the finishing and mounting of jewels some
small elements will often be needed:

- Rings and links.
- Clasps.
- Chains.
- Brooch and earrings fasteners, etc.

All these jewelry implements widely used in
enameling are found in a great variety of styles
and fashions in craft supply stores.

T⸱⸱⸱ HNIQ⸱⸱⸱⸱ for working
SHEET-METAL

NICKEL-SILVER

As we indicated before, nickel-silver is sold in sheets of different size and gauge.

For hand-shears cutting, gauges 24, 22 and 20 only should be used. If thinner, it offers no resistance to deformation; thicker, it has to be sawed, which greatly complicates the work. For room adaptability (and work as well) only rather small sized sheets should be used (about I' by I'). The best gauge would be 22.

Working process

• First using metal shears, cut out a piece of metal, slightly larger than the object to be made. A useful precaution: this metal has sharp edges. Do not handle too roughly.

• Place the slab on a plane surface and hammer lightly to correct the deformation that results from cutting. Don't insist too heavily on the adjustment, as metal hardens with hammering, and this will make it harder for you to give it a definite shape later on.

• Trace very precisely the chosen shape with a ruler or square-ruler and a scriber. It is best to start with simple, angular shapes: squares, rectangles, trapezoids. This will make the cutting out and bulging easier. Circles are of more delicate craftsmanship. After you have mastered the technique and want to get to more complicated shapes, you will have to draw your design on a piece of paper and transfer it on metal with carbon paper.

- Trim the plate, now giving it its final shape. This should be done with metal-shears, cutting slowly in order to get smooth edges.
- Slighty flatten the plate once again before hardhammering the metal, which means shaping it and giving it rigidity at the same time.

COPPER

Sheet copper is worked the same way as nickel-silver. Gauges 24, 22 and 20 are most frequently used. As copper is a more malleable metal, slightly thicker sheets can also be used successfuly.

You should be reminded that many ready-made sheet copper shapes are available at craft-supply stores (mostly used for enameling): squares, circles, trapezoids, ovals, etc. It is always possible to use these in order to spare yourself the cutting of simple pieces. The thinnest ones can then be reshaped by hammering (see next paragraph).

These ready-made copper shapes may also be used when gluing pearl beads and thus you can produce different mountings (using rings) by combining pieces of varied shapes and sizes. They allows for the making of very original pendants, brooches, necklaces and bracelets.

Finally, as we pointed out earlier, and as copper is a quite oxidizable metal, it is best to use a coat of metal varnish in order to protect your clothing from the direct contact with the metal.

FORGING

When a piece of metal is ready, whether copper or nickel-silver, you can then make it curve inwards (belly it), providing it suits your project.

Curved piece:

• Place the piece on the bench-anvil, holding it between thumb and index finger.

• With the other hand, using the ball-peen hammer, (bellied face) strike regularly, working on one place at a time.

• If the piece has a tendency to roll up, turn it over and flatten it with the flat-face.

• When the whole surface is hammered, place the piece on the edge of the bench-anvil to as to leave a few fractions of an inch overlapping it, and round aff the edge of the piece, using the flat-face of the hammer: thus giving the whole piece a curved aspect.

We mentioned in the tool list a wooden forming-block, used in the curving of pieces when a very concave shape is desired. We will explain its use along with the description of some models (see for example page 61).

Flat pieces

These pieces need only to be worked on both sides, without curving the edges. In the case of a thicker piece, (20 or 18 gauge), the edges should be hammered over 1/10 of an inch only with the ball-face of the hammer. It results in a better rigidity of the metal and a good decorative effect (see picture of necklace on page 27), together with leaving the plate flat.

FINISHING

The edges remain sharp and uneven. They should be smoothed out by filing, using a heavy grain, then a fine grain file. Finish with emery cloth. With the perforating pliers (which leave no burr) pierce the hole necessary for either assembling the pieces together or mounting them on a chain.

It would seem easier to pierce holes before hammering, but as the metal is deformed during the forging process, both the size and the place of the holes would then be modified.

MOUNTINGS

Pieces are assembled with jump-rings, which can be either made (see page 19) or bought. For assembling, proceed as follows, using 2 pairs of thin and flat-nosed pliers:

• Holding one pair of pliers in each hand, grasp the ring on both sides, with the opening facing up.

• Open the ring slowly, twisting the pliers upwards and downwards respectively.

• Fit the ring into the hole of the piece to be assembled.

• Using the pliers, close the ring (same method as opening).

The different pieces will be mounted together offering a choice between necklaces, bracelets, pendants and brooches.

For brooches, use fasteners sold in craft-supply stores. They can be secured by gluing on the back of the jewel.

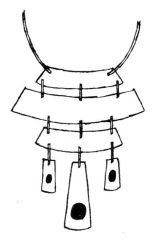

Other example of pendant with cut plates

METAL WIRE TECHNIQUES

We already know that both nickel-silver and copper are used when working sheet metal. However, as copper wire is too soft and cannot hold a given shape, we will use only nickel-silver when crafting objects from metalwire.

Metal wire is available in spools or rolls going from gauge 28 to gauge 12. Some specialized stores even sell it in both smaller and larger diameters.

Choose the thickness of the wire in regard to your project. When beginning, it is best advised to follow the directions given with the mounting examples in a following chapter. Any object can be made from metal wire, from the simplest round or oval jump-ring to the most tooled shapes.

Wire should first be formed with flat or round-nose pliers, or with the help of a mandrel to act as support for its modeling of the wire. We will study again the problem of the mandrel when working on more particular projects.

After having shaped the wire, it should be slightly flattened on the bench-anvil to give it rigidity.

When working on a particular design, you should be careful not to strike the crossed wires too heavily as this will break one of the two. Still the hammering will produce a small shifting and this is due to the stretching of metal.

Of course, the best method would be never to superimpose two wires, but this would prohibit many interesting designs.

In order to fix the two slightly distorted parts, put a point of two-component cement and hold it between tweezers or under a weight until dry.

Let us now show you a few working techniques:

MAKING JUMP-RINGS

Jump-rings are used for assembling parts together. In order to avoid making them by hand, they may be purchased at craft supply stores. However, depending on the object in the making, you may want to make a ring suiting the exact style of the jewel.

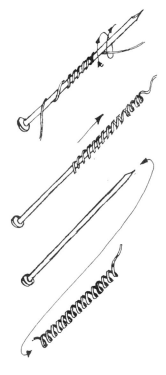

Here's how to do it:

• Wind the wire very tightly around a knitting-needle (for example), choosing its size with regard to the desired size of the rings.

• Remove the coil-like wire from the needle.

• Make a cut through each of the rings, using the tip of the metal shears.

• Slightly hammer each one so that it will hold its shape.

By simply using different sized needles, you will be able to make all kinds of rings - square, oval, rectangular or triangular ones for example. Now is the time to use your imagination and craftsmanship! It should also be noted that oval rings and different styles of chains (sold by the foot) are available at craft supply shops. And it is possible to use the chain-links separately, opening and closing them as shown previously.

Moreover, you can successfuly use the rings and links from antique chains.

MISCELLANEOUS SHAPES FOR DECORATING AND MOUNTING

Very often, several identical pieces will be needed for the same assemblage. This part of the work is most delicate, as it is impossible to know in advance the length of wire needed. It is necessary therefore to proceed by trial and error.

In dealing with this problem the best method is to cut 3 or 4 pieces of wire of the exact same length and to keep one aside, using it **as a standard after the other ones have been used in searching for the right shape.**

Cut then as many lengths as necessary and work on each as regularly as possible.

MAKING SIMPLE HOOKS

These hooks will be used as decorative pieces, assembling links, or pendant ornaments.

• Simple round hook: bend the end of the wire **back upon itself with round-nosed pliers.**

• Double round hook: do the same at both ends of the wire.

• Eight-shaped hook: using the same pliers, twist in opposite directions at both ends.

• Triangular or square hooks etc.: use now the flat-nosed pliers to shape the end of the hooks, proceeding the same way as above, shaping double or eight-shaped loops, or combining styles in order to obtain different varieties of hooks.

SHAPING HOOKS ON THE MANDREL

These hooks are usually called "lyre-hooks" because of the resemblance they abear to this

musical instrument. They are always made with the use of a frame-board, (To make this you will need a small board of thick plywood and some 8D or 10D nails with the heads cut-off, driven into the board according to the measurements of your design).

Wires cut to the right length are twisted round the nails, thus taking the desired shape.

Take then the lyre-shaped hook off the frame and hammer it slightly to make it more rigid.

This method enables you to make as many copies of the same hook as desired.

See in the margin different examples of hooks, and a model of frame-board.

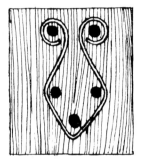

FLATTENED WIRE PENDANTS

These extremely decorative pendants are often used in the mounting of jewelry.
To make them,

• Cut a piece of wire of the desired gauge (the thicker the wire, the wider the pendant). Note that a properly hammered wire flattens easily. For example, a 16 gauge wire can produce a piece 1/4" wide flat. It is necessary to cut the wire slightly shorter than the desired pendant.

**Hook turned
to the right**

• Place the wire on the anvil, holding it between thumb and index finger. Using the flat face of the hammer, strike its end until the desired shape is reached. Take care to turn the wire as often as necessary so that it will not be deformed.

With some experience, you will be able to forge as many different models as you want (more or less rounded shapes, drop shapes, etc.).

After hammering, file both ends of the pendant. Finish with emery-cloth.

These pendants can be mounted in different ways, either by piercing a hole on the flat end with the perforating pliers or by twisting the narrow end with the round-nosed pliers to form a loop.

Used for the mounting, this loop will be placed facing either side of the jewel to produce additional decorative effects.

Assemble these different elements (as well as those made from sheet), combining them perhaps with plates to form very different jewels.

In the case of ornaments used to decorate lapels, the best fastening piece will be an old tiepin or simply a safety pin cut in half and soldered on back of the jewel.

RING MAKING

The metal used here is again nickel-silver, which allows you to make a great variety of very modern rings and to use your imagination and creativity.

Gauges 14, 15 and 16 give the best results: if thinner the wire is too fragile, if thicker it is too hard to work.

The use of a mandrel is necessary, or at least a piece of wood of approximately the same

size (hammer or scriber handle for example).
The ring can be reduced to the finger's size
once it is finished.

• Cut an 8'' to 10'' piece of wire.

• Twist it around the mandrel in shape of a
ring, crossing or not the wire on top.

• Place it on the bench-anvil, flattening it
slightly to fix its shape.

• With the two loose ends of the wire, form
the design to be used as the setting. It can
be twisted together in different fashions and
then flattened with the hammer on one beak
of the anvil.

**Parts flattened
for gluing**

• Once this is all finished, make sure the ring
fits the size of the finger.

Ring settings are made from nickel-silver sheet;
the technique used is the same as the one
used for making medallions. As these, they
may be decorated with cabochons. They will

23

then be glued on rings found in craft-stores (these ready-made rings generally used for enameling).

The ring can also be hand-made with the help of the mandrel. The two ends are then flattened on the anvil and the setting cemented on the flat piece.

See some examples of rings on the photograph page 48.

Another example of wire and plate pendants

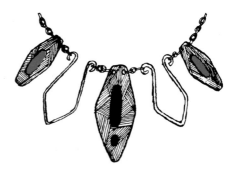

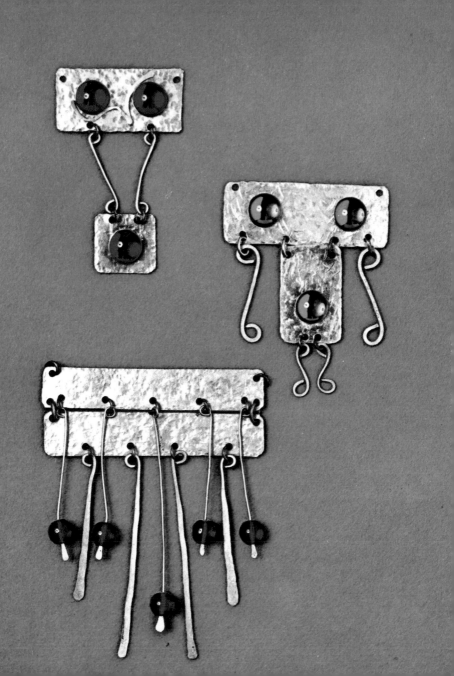

PEARL BEADS
AND cabochons

Metal jewelry can be adorned with beads and cabochons. Either are found in a great variety of shapes and colors thus allowing for many rich and interesting combinations.

MOUNTING OF PEARL BEADS

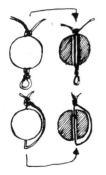

Whether made of wood or glass, round, square, oval-shaped or faceted, the choice is open! Always remember, here is a good way of finding use for the beads from an old fashioned necklace. Don't be afraid to use your imagination in the choice of colors and mounting either. For example, the beads can be strung on a nickel-silver wire, twisting it after each pearl. In the same style, but without twisting the wire, form a loop with the pliers, its size depending on that of the beads. Or, string the beads on both wires and twist on top to hold in place (top drawing). This method enables you to make necklaces and bracelets in a relatively short time.

Pearl beads can ornament a spring-shaped mounting:

• Make a spring, following the method shown for the making of open jump-rings.

• Stretch the spring in order to open it.

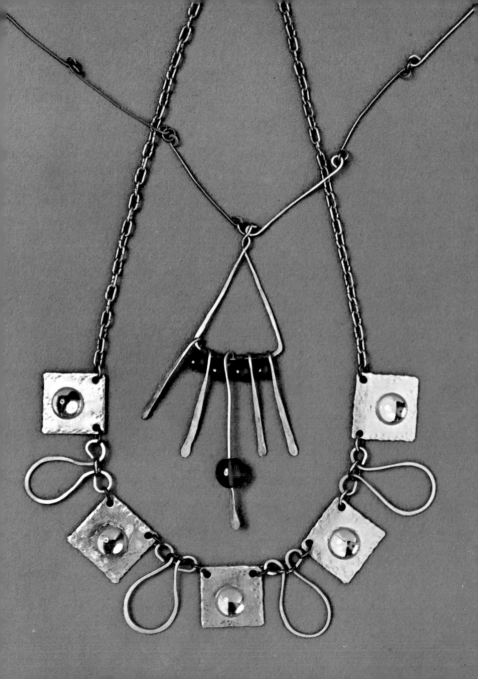

- String the pearls one by one, placing them as desired.

- Now, slightly hammer the spring so that it will keep its shape. Be careful not to damage the pearls, especially glass ones.

If this mounting is long enough, it can be used as a necklace or bracelet. If shorter, it can become a decorative object. In this case, twist each end into a loop. Several objects assembled together will produce another type of necklace.

In the same fashion (pearl-adorned motifs), many combinations are possible. For example:

- Two pearls glued on the ends of an eight-shaped loop. The wire should be chosen according to the size of the pearl-hole.

- Twist a piece of wire, string an oval bead on both threads, bend them back on each side of the pearl-bead and twist the 4 ends in shape of hooks, etc.

Here too all ideas are welcome. The only limitation is the respective thickness of the wire used and the size of the hole in the bead. The designs are then assembled together with round or oval jump-rings.

Beads can also be mounted on rods. They can be used as decorative pendants and ornamental plates (see examples on photographs of different models).

- String a pearl on a wire.

- Hammer one end to prevent the pearl from falling.

- File the end of the wire.

Several beads can be mounted on the same metal rod, whether of similar or different sizes.

But be careful not to break them when hammering the rod: start with the pearl at the end of the pendant.

SETTING CABOCHONS

Cabochons usually are half-spheres, either smooth-surfaced or faceted.

Other geometrical shapes can be found also, but cabochons always offer a flat surface for gluing.

They may be set in a bezel made of twisted or flattened wire (which is pasted around the stone), thus enhancing the appearance of the jewel.

Mosaic beads (which are generally used for enameling and are available in different sizes) can replace cabochons. All are found at craft suppliers.

Examples of these very decorative mountings are presented in photographs throughout the book.

complementary
TECHNIQUES

CHAINS

For reasons of availability, speed, or economy, nickel-silver pendants are often mounted with ready-made chains bought from craft-supply stores.

However, if one wants truly perfect jewels, mounting should be hand-made.

Here are several examples:

The simplest one is the necklace described as number 7 (see page 49).

Chains can also be made from fancier links (several examples of chains are shown on the next page). These links will be assembled together with jump-rings, made as shown on page 19, or bought ready-made. You can see a model of this type of chain on pendants numbers 3 and 12.

It is important, after having made a chain link, to hammer it slightly on both sides.

Here are now a few mounting suggestions:

I - Simple hooks made with 2" or 2½" long wire (18 or 16 gauge).

II - Variation obtained by simply opposing the direction of the hooks. Same length of wire and same gauge as model above.

III - Chain made of a row of 8-shaped hooks assembled with jump-rings. For this type of chain, use 18 or 16 gauge wire, 1" long.

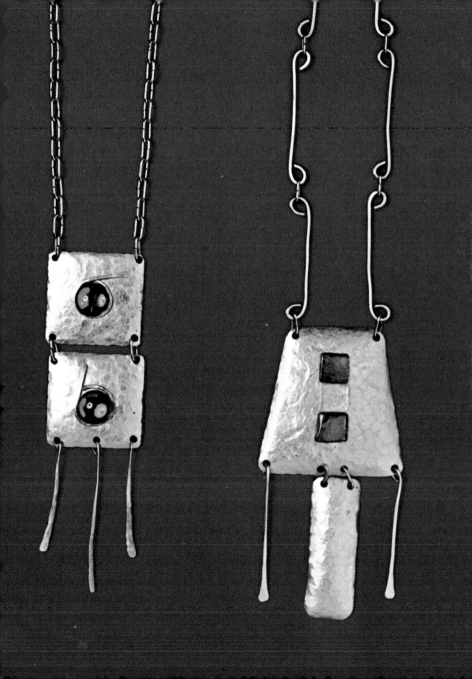

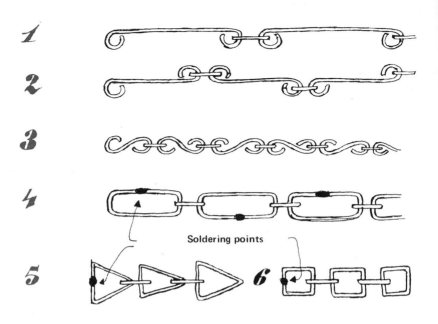

Soldering points

IV - This chain is formed of rectangular rings (use fiat-nosed pliers). The joining of each ring is fixed with a drop of solder. In order to respect artistic equilibrium, invert the position of the point of solder on each ring (once to the left, then to the right, as shown on drawing).

V - Same work, with triangular rings. Here solder at the base of the triangle.

VI - Another example in the same line of style, but using square rings.

When putting together all these chain links, use jump-rings that are as small as possible in order not to alter the general appearance of the chain.

For the mounting of a pendant on this kind of chain, it is best advised to choose a simple

model. On the other hand, a fancy chain can very well be worn alone, as it is decorative in itself.

SOFT SOLDERING

The setting of pearls beads or other ornamental accessories can always be done by gluing. But it is often impossible to join two pieces together - the contact surfaces being too small (for example, this pendant made of five spiraled wire pieces). In this case, solder must be used on the reverse side of the jewel, as indicated by black dots.

For this technique, only a small soldering iron and bobbin of soft solder are needed.

• Place the two pieces to be joined on a small wooden board in the exact position they should be keep after soldering. The best way to hold pieces in position so that they will not be moved or deformed by the heat is to use tweezers or slightly driven nails.

• Heat the soldering iron for about 15 minutes. The necessary temperature is reached when solder flows as soon as put in contact with the iron.

• Place the iron where the soldering is to be made, in order to pre-heat the piece.

• With your other hand, apply the wire-solder to the tip of the iron: it will flow and leave a drop of solder on the part to be soldered.

• Remove both the iron and the solder. Let the piece cool.

If the drop of solder bulges or is too irregular, remove it with a flat and smooth file.

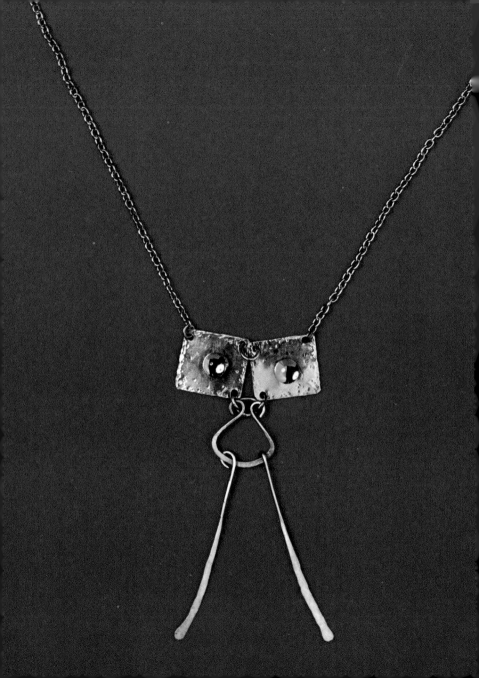

SHEET-METAL

SOME EXAMPLES

We present here a few suggestions of objects to be made from sheet-metal. Some are perfected by adding wire ornaments; however, the basic work is that of sheet-metal.

Let us point out too that the directions given here concern the shaping and mounting of the particular projects presented only. As far as basic techniques are concerned, you should refer to the appropriate technical chapters.

PENDANT NUMBER 1

See the photograph on page 25, upper left.

MATERIALS:

- A 2'' by 3/4'' plate.
- A 3/4'' by 3/4'' plate.
- 2 pieces of wire, 2'' long, 20 gauge.
- 6 oval rings.
- 2 big cabochons.
- 1 small cabochon.

INSTRUCTIONS:

• Once the plates are cut, hammer them lightly, causing them to slightly bulge out. However, be careful to keep a flat surface (on which the 2 cabochons will be pasted), at the center of the larger plate.

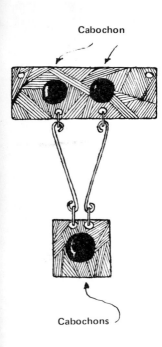

Cabochon

Cabochons

• Pierce the holes used for mounting the chain and jump-rings.

• Take the two wire rods, twisting each end into a hook (use round-nosed pliers), both hooks being on a same plane, but facing opposite directions.

• Slightly hammer the two identical wire pieces to fix their shape.

• Use them to attach the two plates, making them go through the oval jump-rings (the two metal hooks must be symetrically placed on either side of the pendant's axis).

• Close the hooks so that they will not come out of the rings.

• Glue on the cabochons and let dry for 24 hours at room temperature.

• Fix the 2 oval rings on the upper corners of the larger plate for the mounting of the chain.

A necklace may be used in place of chain.

This jewel can also be used as a brooch or lapel ornament, in which case the upper holes are not necessary. Findings should be glued on the back of the plate instead.

Variation: motif number 1.a

See photograph on page 25 (upper right).

Same style as pendant number 1. However, proportions, ornamental details and mounting process differ.

MATERIALS:

• A 2 1/4" by 3/4" plate.
• A 1 1/4" by 3/4" plate.
• An 8", 20 gauge piece of wire.
• Six round or oval jump-rings.
• A large cabochon and two smaller ones.

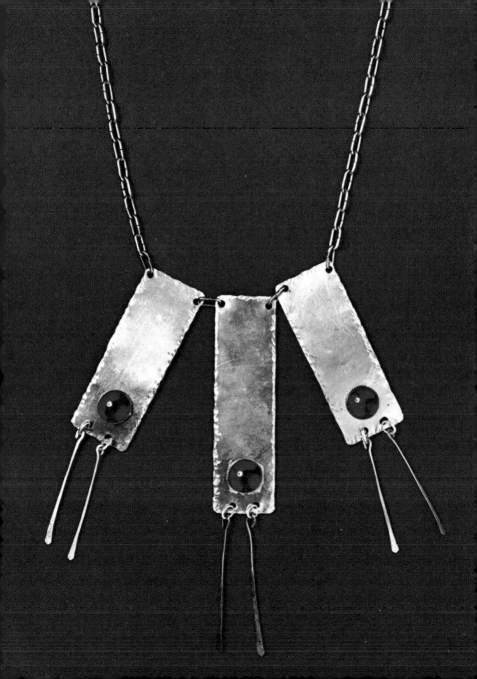

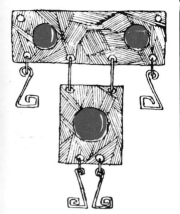

INSTRUCTIONS:

- Hammer the plates and pierce the holes.
- Cut the wire in four 2" sections and form four S-shaped hooks, one of the hooks smaller than the other.
- Hammer the hooks to fix their shape.
- Glue two cabochons on the upper plate.
- Mount the hooks on the lower part of it; then the second plate, using 2 jump-rings.
- Glue the larger cabochon on the lower plate and mount the two remaining hooks. The smaller end of the hook is attached to the jump-ring.

PENDANT NUMBER 2

See photograph on page 24, lower motif.

MATERIALS:

- Two 2 5/8" by 1/2" plates.
- Four 22 gauge metal rods, 1 3/8" long.
- One metal rod, 22 gauge, 2 3/8" long.
- Two stems, 18 gauge, 2 3/4" long.
- Two stems, 18 gauge, 2 1/4" long.
- 5 pearl beads, 3/16 to 5/16" in diameter.
- 4 large oval jump-rings.
- 4 small oval jump-rings.

INSTRUCTIONS:

- Cut and flatten the plates.
- Striking more heavily, hammer the side of the plates on a width of aproximatively 1/10 inch, decorating them with a guilloche.
- Pierce the holes:
- On one plate, one hole on each of the upper

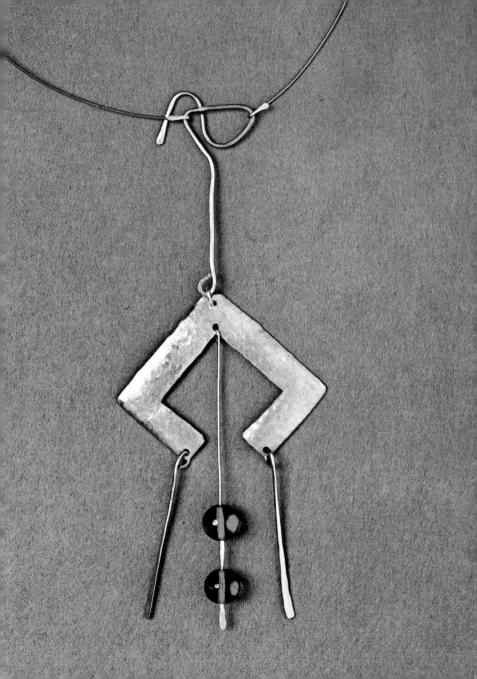

corners, then five equally spaced on the bottom side.

• On the other plate, one hole on each of the upper corners, then four, also equally spaced, on the opposite side (at regular intervals, starting from the middle of the plate).

• Prepare the four 1 3/8" stems: place the bead on one end of the wire; holding it with one hand, hammer it flat so that it won't come out. Form the other end of the wire into a hook, using the round-nosed pliers.

• Do the same with the 3 other stems, as well as with the 2 3/8" one (which should be flattened on a greater length to make it more decorative).

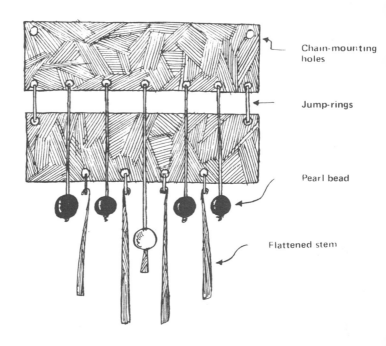

Chain-mounting holes

Jump-rings

Pearl bead

Flattened stem

• Attach the 5 stems to the upper plate, as shown on drawing (the longer one in the middle) using only the hooks and no jump-rings. Close the hooks with flat-nosed pliers.

• Prepare the 18 gauge stems. Make a hook on one end of each, then flatten them on their whole length, regularly increasing the width of the flat.

NECKLACE PATTERN

See photograph on page 27.

This necklace is formed by an alternation of wire motifs and small plates decorated with cabochons. It is a typical example of a style widely used in metal working. Starting from the model described here, you will be able to create many various shapes by simply modifying one element or another.

NUMBER OF PIECES:

The pieces decorating the front part can be 3, 5 or 7 in number, depending on their size and shape. It is always preferable to have an odd number of pieces.

To link these pieces together, use hooks or bits of chain assembled together with jump-rings.

SHAPE OF THE PIECES:

They can take any geometrical form (square, triangular, etc.), or can be completely irregular. In this case, however, be careful to preserve the balance of the necklace.

The pieces can also be of same or increasing sizes, or still, mixed ones. But once again, do not unbalance.

DECORATING THE PIECES:

You can either leave them plain, hammer or curve them, or still decorate them with cabochons, mosaics, or wire pieces.

MOUNTING ELEMENTS:

The different pieces can be simply assembled with jump-rings, but you can also put in various fancier hooks, depending on your inspiration. As you can see, it is possible to form a great number of very different necklaces by simply combining all these elements. You will find on page 85 several suggestions, and on page 37 a photograph of another necklace.

PENDANT NUMBER 3

See photograph on book-cover, motif on the left-hand side.

MATERIALS:

- A nickel-silver plate, 22 gauge, 2" by 1 3/8"
- A piece of wire, 16 gauge, 6 3/4" long.
- 1' of 14 gauge wire.
- Four round jump-rings.

INSTRUCTIONS:

- After cutting out the plate, hammer it as shown previously.
- Pierce a hole on each of the upper corners and two on the bottom side, about 1/4" from the corners.
- Cut the 6 3/4" wire in three equal parts, and make three simple hooks.

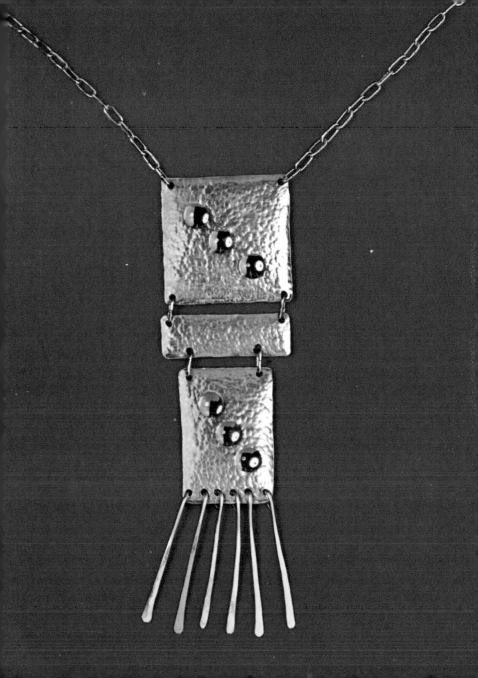

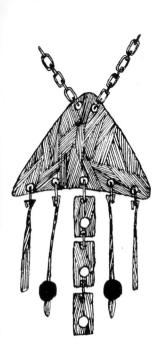

Another suggestion of pendant

• Wind the 1' wire into a spiral, leaving a 1 1/4" length on one end to be hammered.

• Fix this spiraled piece on the backplate with two solder points, one at the center of the spiral and the other on the middle of the straight bit.

• The chain-type hooks will be attached to the bottom holes with jump-rings, one parallel to the edge, the other two as pendants.

• Mount the chain on the two remaining jump-rings.

PENDANT NUMBER 4

See photograph on cover, right-hand piece.

MATERIALS:

• A triangular plate, 2" to each side.
• A piece of wire, 3 1/4" long, 14 gauge.
• 8" of wire, 16 gauge.
• A rather large oval jump-ring.

INSTRUCTIONS:

• Hammer the plate, curving it regulary. The center should be left flat enough for the piece to be pasted on.

• Pierce a hole at the top and five on the base of the triangle (regulary spaced on the whole length).

• Form a curved piece with the 8 1/4" wire and hard-hammer it.

• This piece will be pasted pointing upwards on the backplate.

• Cut 5 equal pieces from the 8" wire. Flatten one end of each piece. Bend the other into a hook (they will be attached directly to the

plate). Close the hooks with the flat-nosed pliers.

• Fix the oval jump-ring on the top hole, and mount the chain.

PENDANT NUMBER 5

See photograph on page 31, right-hand piece.

MATERIALS:

• A trapezoidal plate; 2'' and 1 1/4'' bases, 2 3/8'' height.

• A 1 3/4'' by 5/8'' plate.

• About 3 1/2'' of 16 gauge wire.

• 4 oval jump-rings.

• colored stone diamond shapes (mosaic type).

INSTRUCTIONS:

• Prepare the two plates by hammering.

• Pierce 2 holes on one end of the rectangular plate.

• Pierce 1 hole on each corner of the trapezoid, plus two at the center of the bottom base (same intervals as those on the rectangular plate).

• Cut the wire in half. Shape each part to form a pendant (pliers and hammer).

• Paste the 3 stones on the trapezoid.

• Mount the two pieces together with jumprings. The pendants are attached directly to the holes on the angles.

This pendant is mounted on a chain made of hammered simple hooks, linked with oval jumprings.

Pendant variation

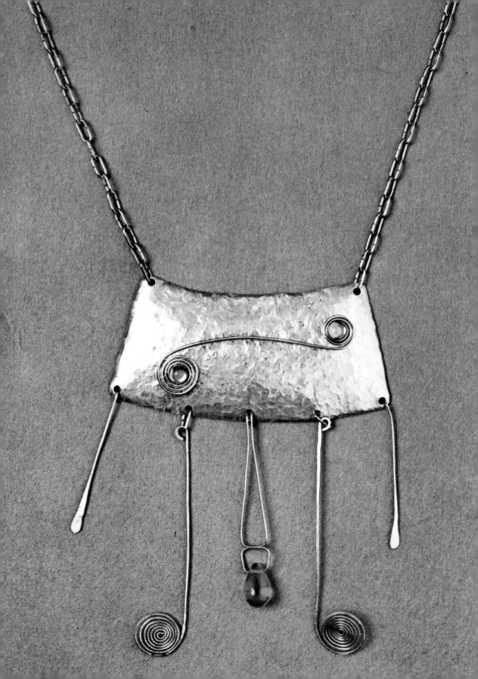

PENDANT NUMBER 6

See photograph page 31, left-hand motif.

This pendant is made of two identical square plates, the lower one decorated with three wire pendants. On each plate is pasted a cabochon set in a circle of nickel-silver wire.

MATERIALS:

* 2 square plates, 1 1/4" to each side.
* 10" to 11" of wire, 23 gauge.
* 2 cabochons.
* oval jump-rings.

INSTRUCTIONS:

* The plates and pendants are made the same way as in the examples above.
* Paste the cabochons.
* In order to set them, take a piece of wire 1/4" longer than the perimeter of the stone. Form the circle with the round-nosed pliers, leaving the extra length straight. Hammer the whole piece, especially on the straight end. After hammering, close the circle again, as is probably widened during the process (use flat-nosed pliers).
* Fix the settings around the cabochons with a drop of cement. These settings give a final touch to the jewel and enhance the stones.
* Attach the 2 plates together with jump-rings.
* Cut the three wire-pendants from the piece of wire: the center one is about 2" long, the two others about 1 1/2". They are worked with hammer and pliers and mounted directly on the respective holes.

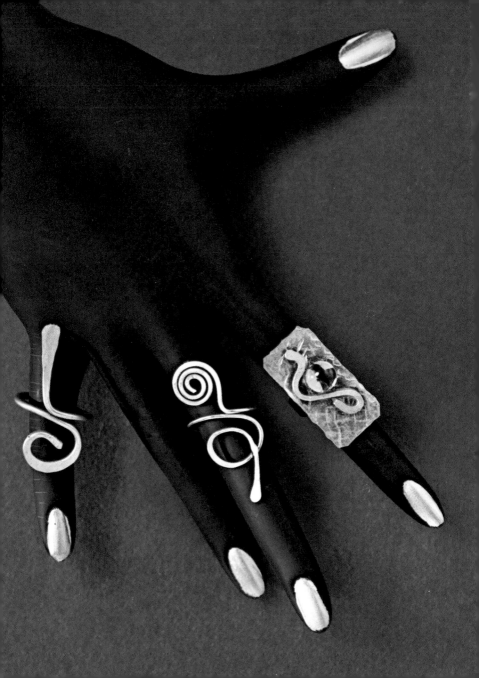

PENDANT NUMBER 7

See photograph on page 34.

This pendant is formed of two identical square pieces. The lyre hook is decorated with 2 wire pendants.

MATERIALS:

- Two square plates, 3/4" to side.
- About 3 1/4" of 18 or 16 gauge wire.
- Two pieces of wire, 16 gauge, about 3" each.
- Four oval jump-rings, two small and two large.
- 2 small cabochons.

INSTRUCTIONS:

- The plates on this pendant are hammered on the sides, for decorative purposes only.
- Paste the cabochons on the center part of each plate.
- Pierce holes on three corners only.
- Form the lyre hook, using the 3" wire. Hammer slightly the hooks on the ends, and harder on the curved part.
- **Using a 2 3/8" long piece of wire, form the hooked-on wire pendants (same method as usual).**
- Place each plate with the two-holed side facing upwards, and the corner which is not pierced farthest from the lyre-hook.
- Assemble the two plates together with a large oval jump-ring.
- Using two small rings, mount the lyre-hook; make the second large jump-ring go through the small ones to insure stability to the mounting.

Suggestion of pendant, made from plates. The matching bracelet can be made also.

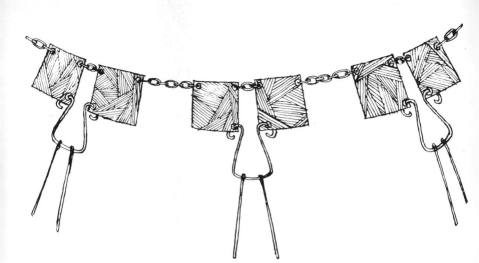

● Make the hook part of the wire pendants large enough so that they can run freely on the lyre hook. Then close them with the pliers so they will not fall out.

This motif can be tripled to form the base of a multiple-piece necklace. In this case, make the wire pendants on the side pieces slightly shorter, and assemble the three pieces with five jump-rings (see drawing below).

PENDANT NUMBER 8

See photograph page 39.

This pendant is mounted on a neck-ring made from nickel-silver wire following the method described on page 68. Here, the wire has simply been flattened on both ends to form the flat hooks: One is tightened to the fastening hook on the piece; the other is left open just wide enough to allow for the putting-on and taking-off of the necklace.

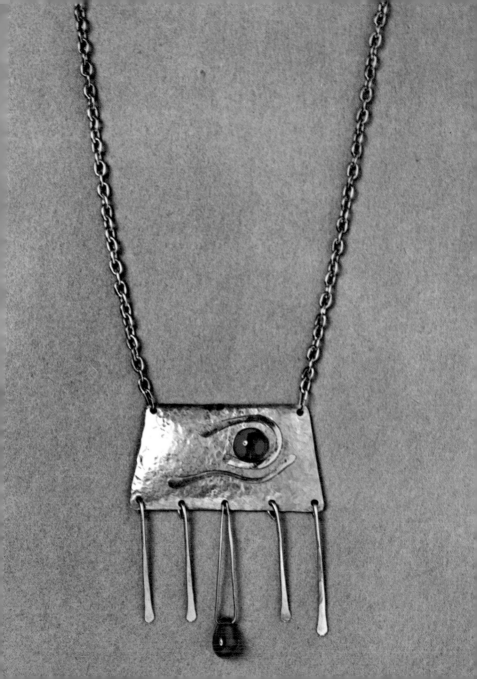

Necklace

Closed hook Hook

The fancy wire piece used to join the pendant and neck ring together is shaped with pliers and hammered. Be careful to place all assembling spots (of both neck ring and piece) on the same level to insure balance to the necklace.

MATERIALS:

- Nickel-silver wire, 18 or 16 gauge, 6 3/4" long.
- Two pieces of wire, 22 gauge, about 2 3/4", to make the wire-pendants.
- Another piece of the same gauge, about 4 1/4" long, used as support for the beads.
- A round jump-ring.
- A 22 gauge plate, 2" to side.
- Two large beads.

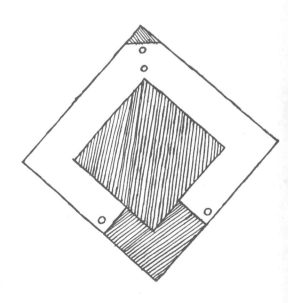

INSTRUCTIONS:

• The nickel-silver plate forming the center part of the pendant is worked as follows, using the drawing on page 52:

• Prepare a 2" by 2" square;

• Draw a 1 1/4" by 1 1/4" square at the center of it;

• Cut out the hatched parts with the metal shears;

• Pierce the holes where indicated.

• Hammer as you would usually do. Here the piece is very slightly curved.

• Make the assembling hook and the pendants as described in previous examples.

• Be careful not to break the beads on the middle pendant when hammering the flats which hold and separate them. Use the ball-side of the ball-peen hammer and protect the bead with a piece of cloth.

• The medallion part and the fixing-hook will be assembled with a round jump-ring to insure elasticity to the whole.

• The wire pendants will be mounted directly on their respective holes.

This piece may also be attached directly to a chain instead of a neckring. if so, the fixing-hook should be made more simple, and much shorter.

PENDANT NUMBER 9

See photograph page 43.

This one is made of three strongly hammered plates.

Its appearance is quite different from the pendants we have seen up to now: the concave face of the plates is used as the right side, instead of the convex one.

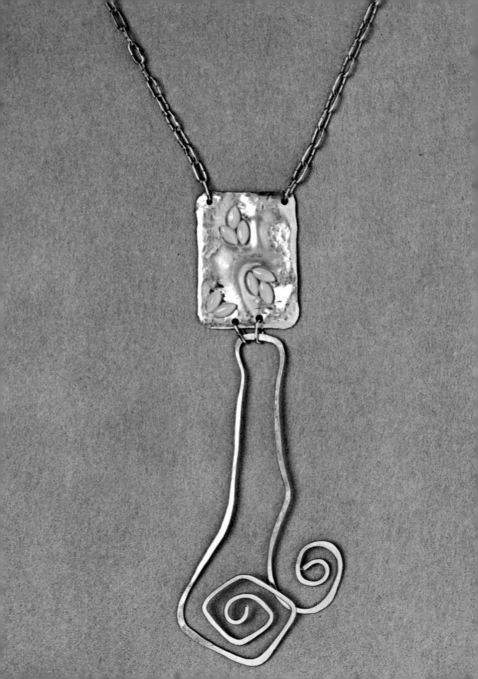

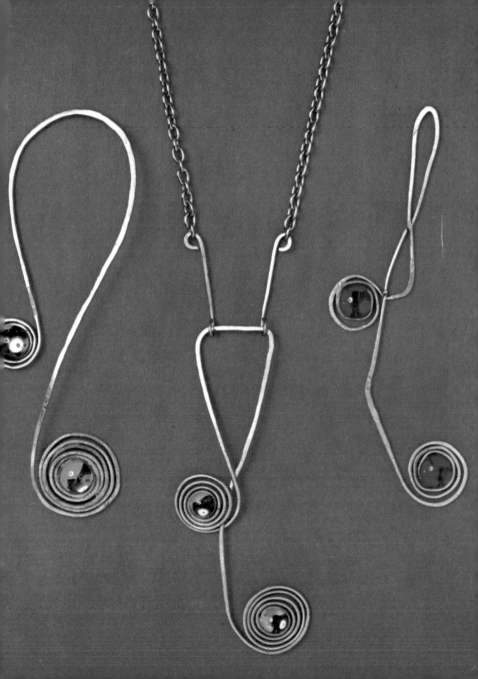

MATERIALS:

• A nickel-silver sheet, 22 gauge, from which we will cut out:

• A square plate, 1 3/4" to side.

• Another plate, 1 3/4" by 1 1/4".

• One foot (1') of wire, 16 gauge, to be cut in 6 equal parts.

• 6 Cabochons.

• 6 oval jump-rings.

INSTRUCTIONS:

• Work the plates in the usual way.

• Pierce the holes for mounting. Place them so that the ones on the bottom of the upper plate will correspond to the ones at the top of the lower plate to respect the balance of the whole.

The holes used to attach the 6 wire pendants are made quite close to each other (about 1/4 inch apart). The pendants are mounted directly without jump-rings.

• Assemble the 3 plates with the oval jump-rings.

PENDANT NUMBER 10

See photograph on page 46.

• This nice and quite fancy model is made of a hammered plate decorated with wire motifs and cabochons. Simple and spiraled wire pendants are used as ornaments . A pear-shaped bead (also called drop shaped bead) decorates the middle one.

MATERIALS:

• 22 gauge nickel-silver sheet.

Nickel-silver wire, 20 or 22 gauge:
• A 1' long piece for the design on the plate;
• Two 2" ones (simple pendants);
• Two 14" ones (spiraled pendants).
• Choose the gauge of the wire forming the middle pendant with regard to the size of the hole in the pear-shaped bead; it should be left free to move up and down the rod. Once you have found the right gauge, cut a piece about 6 1/4" long.
• A pear-shaped bead.

INSTRUCTIONS:

• Prepare the back-plate by drawing a trapezoid on the sheet of metal: respectively 2 3/4" and 3 1/2" for the bases and 1 3/4" for the height.
• Draw the curves as shown on drawing.
• Cut out the hatched parts. Try to get a regular curve. Take out about 3/16" in the middle of the top side and 3/16" on either side at the bottom.

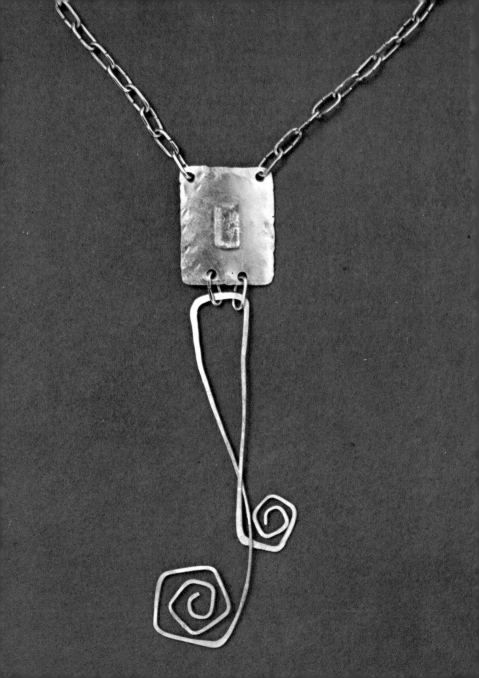

- Pierce holes where indicated on the drawing.
- The plate is hammered and given its bellied shape as usually done.
- Its motif will be modeled on the photograph on page 46. Fasten it with points of solder (hidden with cabochons) or glue.
- Make the straight pendants as usual and attach their hooks directly to the plate.
- To shape the spiraled ones, first form a loop as tiny as possible with the pliers. Then hold it with flat-nosed pliers and wind the wire. Hammer lightly. These pendants are mounted on jump-rings to increase their mobility.
- Middle pendant: place the bead at the center of the 6 1/4" wire; bead both ends with the flat-nosed pliers on a 1/4" length. Using the same pliers, cross the wire on a horizontal level. Bring together the two ends and shape a single hook with both.
- This double hook is attached directly to the center hole on the plate. Make the hook loose enough to give the pendant mobility.

Variation: pendant number 10a

See photograph page 51.

Same style as above, although smaller and more simple.

- The plate is also a trapezoid (bases respectively 2 1/8" and 2 5/8"; height 1 3/8"). A cabochon and two strongly hammered wire motifs are used to decorate it.
- Four flat hooks ornament the bottom base. Make the corner ones 2" long and the 2 other ones slightly shorter.
- As done previously a pear-shaped bead decorates the middle pendant, but here the wire is simply bent without crossing.

59

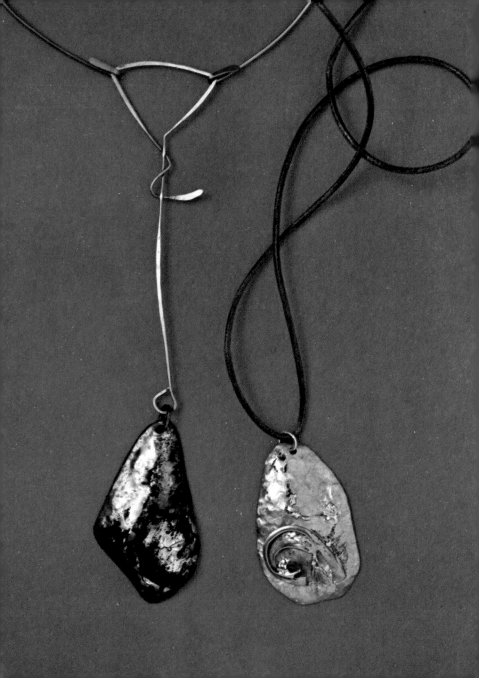

• The five pendants are hooked directly to the plate.

As you can see, a basic model may be used in many different ways by simply modifying its measurements and applying different decorations.

PENDANT NUMBER 11

See photograph on page 54.

Here is another type of pendant. The metal plate (a 1 1/2" by 1 3/4" rectangle) has been slightly rounded at the corners and strongly hammered in an irregular fashion to produce bumps and hollows. It is here useful to have the help of the forming-block.

Small oval-shaped beads are glued in some of the hollows. The piece is made of a long piece of wire hammered and twisted together. It is attached to the plate with two large oval jump-rings.

Variation: pendant number 11a

See photograph on page 58.

Same type as above, but the plate here is 7/8" by 1 1/8" and flattened on the edges only. It is decorated with a mosaic glass-diamond. Same wire motif as above.

This is merely a sample of what can be made by starting from a similar project.

PENDANT NUMBER 12

See photograph on page 60.

This model is very different from everything we have studied up to now. It is made of an irregularly cut out and hammered plate mounted on a simple leather lace.

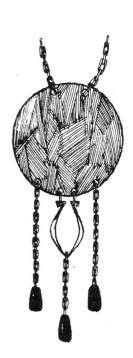

Other example of pendant with hammered plate

61

The added piece is made of metal bits, their edges flattened so as not to be too sharp. These bits are then roughly soldered together and the traces of solder used for decoration purposes.

Starting from this principle, an endless variety of mountings can be found.

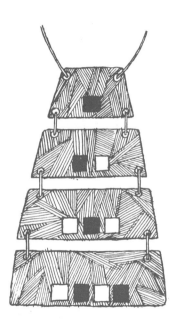

Pendant variation

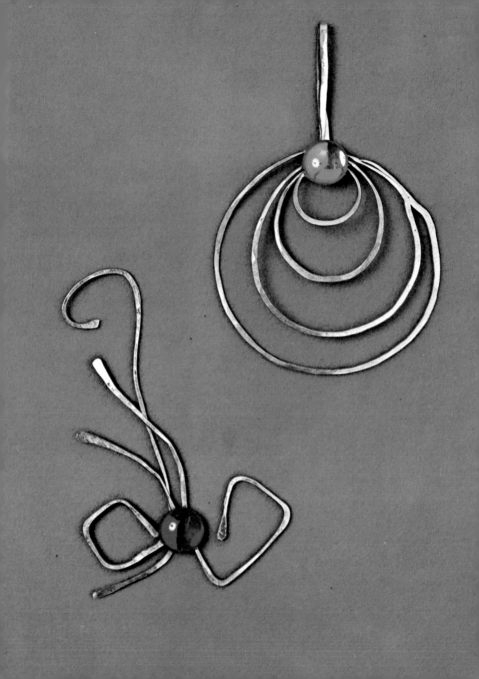

METAL·wire PROJECTS

In this chapter, we present examples made of wire exclusively; only the gauges are different. As in the previous chapter, we give only the instructions concerning each particular project. For basic techniques, please refer to the chapter METAL-WIRE TECHNIQUES (p. 18).

PENDANT NUMBER 13

See drawing on page 65.
This pendant is made with wires of different thicknesses, and pearl-beads.

MATERIALS:

- 5 beads.
- Nickel-silver wire, 6 1/4" to 8" long, 16 gauge.
- Two pieces of wire, respectively 3" and 4 1/2" long, in 20 gauge.
- A single piece of 16 gauge wire, 6 1/4" long.

INSTRUCTIONS:

- Four hooked-on pendants, cut from the 6 1/4" wire, two 1 3/8" and two 1 3/4" pieces.
- Form a simple hook on one·end only of each stem.
- Flatten the other end to form a kind of spatula. Hammer perpendicularly to the plane of the hook. You will thus get two pendants about

64

1" long, and two others about 1 3/8" long —
two short and two longer ones.

● The 3" wire piece will be used as a middle
pendant. Slightly flatten one end so that the
bead won't fall off. Form a simple hook at the
other end, on a plane perpendicular to the flat
side on the opposite end.

● Take the 6" to 8" long wire to make the pen-
dant's body. String as follows: a long pendant,
bead, short pendant, bead, the middle pen-
dant, bead, short pendant, bead, long pendant.
Group them on a 1 1/2" length at the middle of
the wire.

● Using the flat-nosed pliers, bend the two
ends to form a right angle, then form two
hooks on a plane perpendicular to the pearl
and pendant mounting. Forge the bare parts
of the wire. Cross the hooks and fix the
crossing of wires with the hammer (slight
strokes) or a point of glue.

● These hooks will be attached to the mounting
link, which is made as follows: form a flat hook
on each end of the 4 1/2" wire and cross them,
thus shaping a loop.

● Attach the chain to each hook (see drawing).
Here, the chain is an assemblage of double
hooks linked by small, round jump-rings.

Mounting link

PENDANT NUMBER 14

See photograph on page 63, top design.

MATERIALS:

● 12 to 14 inches of 16 gauge wire.

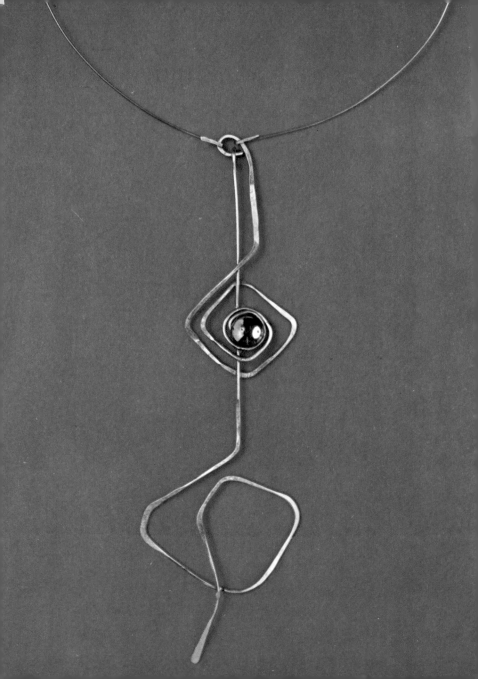

- A 4 1/2" long piece, gauge 15 or 14.
- A flat cabochon.

INSTRUCTIONS:

- With the 1' long wire, form 4 concentric circles of increasing sizes, the center one being the smallest. Both ends of the wire are placed at the top of the motif (see opposite drawing).
- Temporarily hold the circles in place with a piece of string.
- Slightly flatten each ring, trying to make it wider towards the bottom.
- Flatten heavily the small center circle, on which the cabochon will be pasted.
- Make the mounting ring from the 4 1/2" piece of wire. Flatten it on the whole length and bend it, making one end about 5/8" longer than the other, thus forming a long and narrow hook.

Profile of
the jump-ring

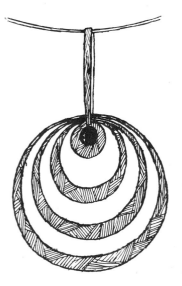

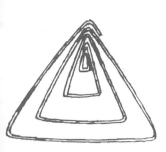

Variation

Be careful not to break the flattened wire with the pliers.

• Replace the string on the concentric design by a point of either glue or solder.

• Attach this piece to the mounting hook, which will be secured with glue or solder.

Increasingly larger triangles, their base decorated with beads, can make an interesting variation of this jewel.

NECK-RINGS

Their advantage is that they allow variations by sparing you the use of chains and hooks. However, they do not suit all styles of pendants. As to when they should be used, the choice is yours to make.

MATERIALS:

The ring itself will always be made from non-annealed nickel-silver: it has kept its spring effect, and will not be deformed.

Gauges 20 and 18 are generally used here, as nickel-silver is too hard for this type of work when thicker.

INSTRUCTIONS:

• Cut a piece of wire, about 1 4/10" long.

• Shape the circle, working the wire between thumb and index finger.

• Flatten both ends on the same plane as the circle, then bend them to form outward hooks (see drawing, opposite page).

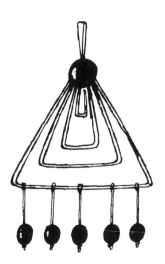

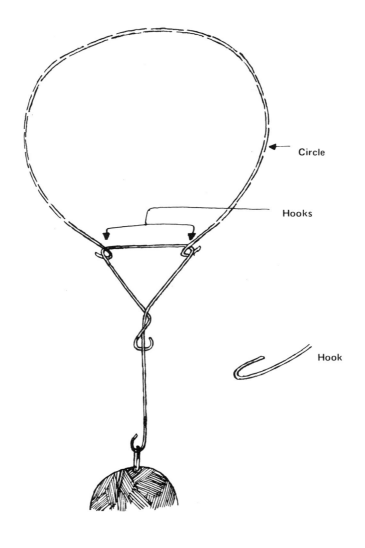

Circle

Hooks

Hook

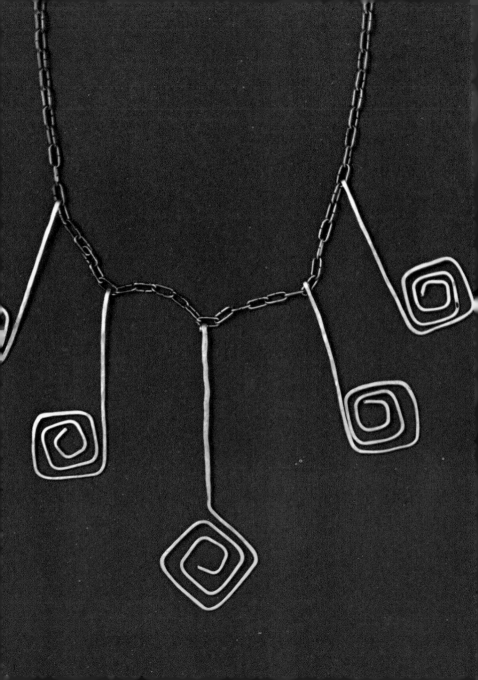

PIECES

See photograph on page 55.

These three examples show you what can be made with a simple piece of 16 gauge wire and two cabochons.

These pieces can be used as pendants, or decorate a neckline or lapel.

INSTRUCTIONS:

This method is very simple:

• Take a 12 gauge wire stem. Form a tiny hook on each of its ends with round-nosed pliers.

• Using flat-nose pliers, tightly wind the wire around the hook on the same plane. Do the same on the other end of the wire. The two pieces should be of different sizes.

• Bend the wire between the two pieces, choosing whether to cross them or not.

• Flatten the wire striking hard enough to fix its shape. But be careful with the crossing points!

• The pieces should not be hammered too hard, as that will deform them.

• Glue the cabochons.

KNOT PIECES

See photograph on page 63.

Lapel ornament made from 14 gauge wire:

• Two 6" pieces.
• One 3 1/2" piece.

INSTRUCTIONS:

• One end of each of the wires is bent with round-nosed pliers (see the drawings on page

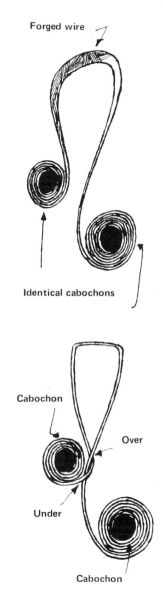

Forged wire

Identical cabochons

Cabochon

Over

Under

Cabochon

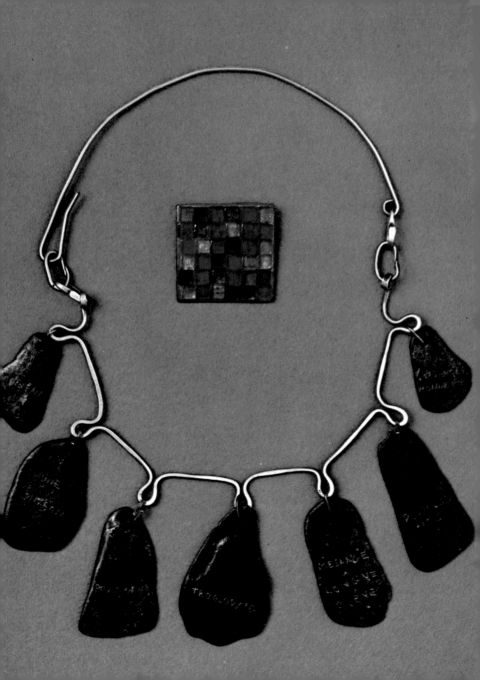

73, showing examples of pieces before assemblage).

• Hammer hard, insisting on bent parts. As we will experience, it is very difficult to give these pieces a determined shape, as it varies according to the pressure of the blows. A point of solder will be needed to assemble them.

• Hide the solder point with a pasted-on cabochon.

This piece can be sewn on the lapel. It can also be held with a soldered-on tie-pin; but these are hard to come by. A safety-pin, cut in half (use the sharp half), can be used instead.

PENDANT NUMBER 15

See photograph on page 66.

This pendant is made of two wire stems mounted on a wire necklace. The first stem is hammered to an almost irregular shape and decorated with a cabochon, the second is identical in style but worked to a different shape.

MATERIALS:

• Two 16 gauge stems; one is 12" long, the other 2 inches shorter (10").

• One cabochon.

INSTRUCTIONS:

To shape the upper piece, use the 1' long stem, working it into a spiral (begin with the round-nosed pliers). Then use the flat-nosed pliers, leaving 1/4" space between rounds, even working irregularly. Finish with a straight length and a flat hook which will be attached to the necklace. Paste a cabochon on the middle of the design after finishing the mounting.

See drawing on page 75.

• Bottom piece: first make a hook, which will be attached to the upper design. Leave a straight stem, about 4" long, and wind the end to form a single loop, following a pattern somehow identical to the first design. The end of the loop is left straight and on the same line with the 4" one.

• Hammer the design: light strokes on the straight wire, then heavier ones on the piece itself, varying the pressure of the blows in order to get a more decorative pattern.

• When assembling the parts, put the 4" wire through the upper piece. It will be held in place with a point of solder hidden with the cabochon. The hook is then attached to the one on the top piece.

PENDANT NUMBER 16

See drawing on the left.

This pendant is formed by two pieces linked by an oval jump-ring. It can be worn on a chain or a neck-ring.

MATERIALS:

• About 10" of 18 or 16 gauge wire.
• Another piece, about 1'3", same gauge.
• One oval jump-ring.
• A large bead.

INSTRUCTIONS:

• For the top piece, fold the longer piece of wire in two, one end longer than the other by 1/4". Using the flat-nosed pliers, wind the two wires together as shown previously. Make one round, then leave one end to the top. Wind the remaining end towards the bottom until it is in the prolongation of the top one. Hammer

a flat large enough for a hole to be punched at the tip of the bottom wire.

Form the end of the top wire into a triangular hook.

• Bottom design: wind the wire following the usual method but do not make the rounds too tight. Leave about 2" of wire free. String the pearl-bead and hammer the tip to a flat end.

• Attach the two pieces with the oval jump-ring going through the hook of the top one and the first round of the bottom one.

WIRE NECKLACE

See photograph page 70.

This necklace is made of a thick chain and spiraled pendants that are attached directly to it, long pendant at the center and four smaller ones.

Many of the pieces described previously can be made into necklaces the same way as this. For this type of necklace, always prepare an odd number of pendants.

**Hook for
the upper piece**

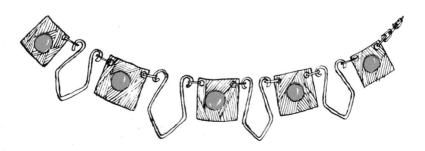

Variation of pendant with alternating plates and wire pieces

to conclude, various suggestions

Superimposition by gluing

As you may have found out from the few ideas we gave you (and probably from our own as well), there are no limits to the number of mounting possibilities with objects made from nickel-silver.

A plain and purely designed jewel will bear that well-balanced, discreet and "classy" look given by the metal itself.

A decoration made of metal on metal can also be an interesting achievement, made either by pasting several pieces on top of one another to get an embossed-like appearance, or by using wire designs to form pieces or initials. In this case, hammer the design and paste on the backplate.

Moreover, as we have seen before, nickel-silver can be enhanced by all kinds of cabochons and pearl beads, whose brightness will contrast with the patina of the metal.

Of course, the use that can be made of metal is not confined to these types of decorations, and as you may imagine there are literally thousands of possibilities. Here are a few ideas, which are yours to develop:

• Paste on a slightly hammered plate-pendant one or more smaller enameled plates. The enamel-metal opposition will result is a very decorative effect.

• You can also use small mosaic glass diamonds either pasting them on as they are (approximatly 3/4" by 3/4") or cutting them with special pliers to get the desired shape.

They are available in great varieties of colors and are found in hobby shops or craft supply. stores.

• In the same line of work, you may also use stones, the kind which are used for the decoration of enamel (see for example the brooch pictured on page 72).

Of course it is not necessary to hide the metal-plate entirely: several small pieces laid out to form a design will be sufficient (see examples on page 76). By using this method directly on copper pieces that are ready-made for enameling practice, you will be able to make in a short time different brooches, pendants, necklaces, etc.

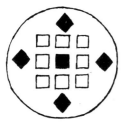

Gluing of wire pieces

• Some natural materials also suggest other possibilities.

For example, mount on a chain or a neck-ring a medallion made of a pretty stone, a pierced pebble, or several ones cemented together.

Gluing of glass mosaics

Exploring beaches or the banks of a stream will often allow you to discover objects which will be mounted with much success.

Mere pieces of glass eroded by sand and water will offer interesting possibilities.

Aside from this you may find enjoyable the use of stones available at craft supply stores at reasonable prices.

One of these stones or a nice pebble can be mounted as a setting: make a nickel-silver ring and flatten its ends, which will be cemented on each side of the stone (see drawing, opposite). A small piece of polished wood, providing its shape is interesting enough, can be made into a pendant or plate ornament.

• Tiny pine cones, strung on metal wire pieces assembled together to form a chain, will make a surprising but nevertheless charming necklace. Do not forget to varnish the cones.

• You can see on photograph page 72 a necklace made from 14 gauge wire on which are hooked small pieces of slate. Designs have been engraved on each of them with a fine scriber.

• Last but not least, we will study the technique of etching. It gives beautiful results, but great precautions must be taken in order to avoid unpleasant surprises when using nitric acid, which is a rather dangerous substance (it burns the skin and its fumes are poisonous). Try to avoid the handling of acid by the younger ones in the group. However, with more mature people, it will allow interesting experiences:

Get some acid and a pair of plastic tweezers from a craft supply store.

Keep the acid in a plastic or glass jar with a lid to prevent the inhalation of fumes. Acid can be used several times. Always work fast and in a well-ventilated area.

Also prepare a 20 or 18 gauge metal plate of the desired shape. The plate must be flat.

Cover it with a sheet of adhesive plastic (both sides, including the edges). Draw your design with the tip of a sharp blade and remove the pieces of plastic sheet from between the lines of your drawing.

With the tweezers, place the metal in the acid solution. The uncovered parts (your design) are attacked by the acid. Keep the plate in the acid until it has eaten the metal to half its thickness.

Remove the plate with the tweezers and rinse it carefully under running water.

Remove the remaining pieces of plastic: the design appears hollowed out.

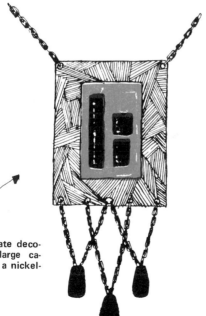

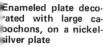

Enameled plate decorated with large cabochons, on a nickel-silver plate

The corroded parts can be tinted by spreading a coat of ordinary paint on the whole surface and then rubbing with a piece of cloth so that it will remain only in the hollows.

Fix the paint with a coat of varnish (use a soft brush or better, a spray can).

To finish we should add that, although we spoke mainly in these pages about jewels — pendants and necklaces — metalworking allows other creations:

You can create belt plates, to be glued on a leather band or even a whole belt made of plates assembled together with chain mountings.

You can also attach more or less shaped plates, decorated with pendants, on earring mountings.

To conclude, we will repeat that in the line of custom jewelry only a research of aesthetics and the notions of good taste will limit your imagination. Apart from this, everything is permitted, every possibility can be investigated, tried for, and finally created.

And now, the game is yours!

A FEW WORDS
about JEWELS

Although not attempting here to write a complete history of jewels, is is of interest to add a few notes about these forms of adornment.

ORIGIN AND MEANING OF CERTAIN JEWELS

As we said in the introduction to this work, the origin of jewels probably antedates recorded history. However, traditions tell of such and such origin and give the symbolic meaning of particular jewels. We often have forgotten that meaning today, although the same use is made of the object itself.
Of course these notions are not always very scientific, but they certainly lack neither romance nor interest.

The ring

From what historians say, its first and quite recent appearance was made among people of advanced civilization.

It was not considered at first as a jewel but as a very personal object. In fact, it seems to have been derived from the seal.

In ancient times (and the Egyptians practiced this custom), monarchs and important noblemen used to seal their documents with a stamp, generally a stone engraved with their personal emblem.

This seal was equivalent to a signature today, and was preciously kept to insure its owner against theft or irresponsible use.

It was fastened to a string or lace and worn around the neck or wrist. As it had to be handled frequently, it was thought possible to wear it on a finger, still using a lace. The lace became too much trouble, and was then replaced by a metal ring.

Little by little, as the appearance of the ring on a hand was agreeable, the seal became a ring.

The use of the seal has not been completely lost: the sigillaria or signet ring used by noblemen to print their coat of arms on official documents bears the same origin.

Throughout history, rings were made for other purposes as well: poison-rings, perfume-rings, etc. some have been made to hold sundials and, later on watches, without prejudice towards purely ornamental rings.

Wedding rings

The small ring worn by married people on the fourth finger of the left hand seems to have a totally different origin.

Because of its shape, the Ancients considered the circle to be the symbolic representation of perfection and eternity. Putting a ring on the fingers of the married couple would thus be the symbol of an ideal made of Man and Woman, together with that of an engagement taken in the face of life itself.

Others think too that this ring is but a smaller version of the bracelet which captive women were made to wear on the arm or leg, thus showing their belonging to such and such tribesman.

Be that as it may, Egyptians were the first to wear wedding rings, their use then spread little by little.

In Rome, the gold ring was a personal distinction, and only the members of upper classes were allowed to wear it.

Christians adopted its use around the year 900. The habit of wearing the wedding ring on the fourth finger of the left hand came from the fact that Ancient Greeks believed that from this finger sprung a vein which was directly connectered to the heart.

It is common today to wear a wedding-ring as sign of marriage; however, depending on the countries, ring-wearing may hold different meanings.

Bracelet

It has been both a sign of slavery and a special distinction.

At the time Rome was founded, a gold bracelet was a military reward for legionaries who had shown particular courage on battlefields; one could judge the valor of a soldier from the number of bracelets he wore. A certain Sicinius Dentatus is supposed to have earned 160 of them during his military career!

The question is: was he able to wear all of them at the same time?

Bracelets had the same meaning for the Gauls, who loved to show the ones they had earned in their fighting.

However, Merovingians used bracelets as ornament only. The famous Saint Eloy himself is said to have crafted rich ones for his King, Dagobert and the Lords of the Court.

The wearing of bracelets then became more and more common. They soon were decorated, as other jewels, with enamels of such a price that Charles the 9th, then King of France, had to produce an ordinance forbidding their use.

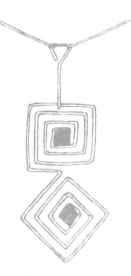

Variation
of wire pendant

Earrings

Here, the legend outgrows the tradition; but the story, which comes all the way from the times of Abraham, deserves to be told:

Sarah, although she was the one to have brought the slave Agar to her husband, grew immensely jealous when she gave birth to Ismael, son of Abraham.

In order to humiliate the slave, Sarah ordered that her ears be pierced and rings (such as the ones used for cattle) put through the holes.

Unfortunately, Agar was very pretty; and far from disfiguring her, these ornaments (which had been inflicted as punishment) only enhanced her beauty — so that all women in the tribe had their own ears pierced as well.

Earrings had been created.

Jewels: for whom?

Only a few years ago, jewelry seemed to be the appanage of women only. Apart from watchchains, tie-pins and signet-rings, men showed only disdain for such trifles.

Curiously enough, as we have seen already, most jewels were masculine in their creation. This fact is real: the right to wear jewelry was at first a privilege given to men only, who would adorn themselves in order to draw attention, and kept the most beautiful stones for their own use.

For women, conquering this privilege has not always been an easy task. Do you know that the first ladies to wear diamonds in public aroused a scandal?

The French Revolution of 1789, which brought about much austerity, even made the wearing of jewelry dangerous: a simple silver shoe-buckle could arouse suspicion of the wearer and make him look like an aristocrat.

Some necklace suggestions

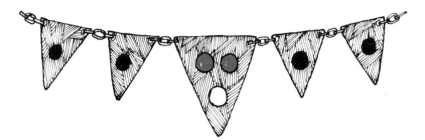

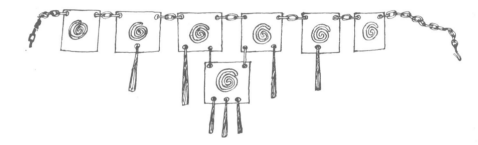

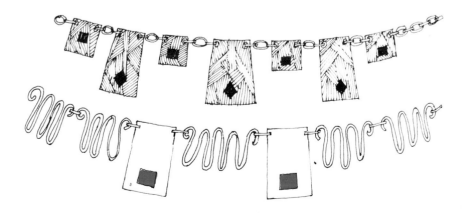

Since the birth of the "hippie" - fashion, men have started to wear jewels again! What's to become of it? It should be worth examining in the years to come.

It seems that women, anyway, are not willing to let go of their conquest.

Fancies old and new

We said at the beginning of this book that imagination and fancies had renewed the style of jewels.

We merely rediscover primitive jewels (or more recently those made by people in far-away places) rather than invent them.

Prehistoric man already used stones, shells, small bones and teeth as decorative elements; in fact, be used anything he could lay his hands on.

Richly colored insects were used in place of beads in Equatorial America, and in North America, pine cones were strung to make necklaces.

The notion of the richness of the materials varies with the exterior contingencies: wood for example is used as ornament wherever it is scarce, and it is used as currency or to decorate ceremonial masks; in certain parts of Africa, a small white shell is most valued. It was brought there from the Indian Ocean by Egyptians traveling on the Nile and Congo rivers.

Let us recall too the marvelous ornaments made in Tahiti from simple tiaras and hibiscus flowers, which bright colors are used as substitute for precious stones and even shells or knuckle-bones. Indeed this custom was dictated by natural resources.

Example of wire pendant with pearl beads

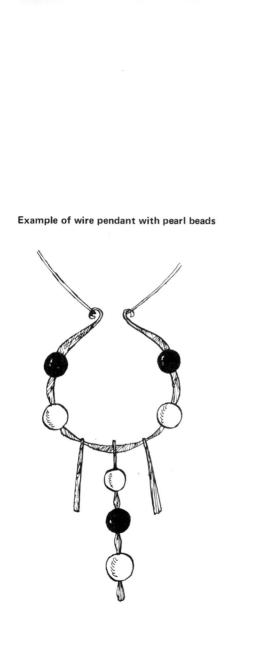

GEM STONES

Very early, man discovered that the light-play and color of stones enhanced his jewelry.

Although only admiration for their beauty was expressed at first, magical and medicinal powers were very soon attributed to different stones. Would it be too strong a statement to say that these beliefs, judging from certain magazines and astrological predictions, have not completely vanished?

Here are anyway a few samples, sometimes naive and strange, sometimes amusing as well.

Four stones only have been classified as precious: diamond, emerald, ruby and sapphire. All others are classified as semiprecious.

Precious stones deserve a weight-measure of their own: the carat, equal to 1/5 of a gram. When spelled "karat", it is used for weighing gold and has a different meaning.

Diamond

The most precious of stones. Its name is supposed to mean "invincible" or "indomitable", with probable reference to its hardness.

As a rare stone, it was considered to be the most valuable good-luck charm, and was conferred with all kinds of powers: preventing spells, annulling of poison, helping victory and making wild beasts flee. A legend even claimed that it would ooze when put next to poison.

Moreover, it would lose all its powers if touched by impure hands; this would go to explain why its owners didn't always enjoy the

privileges which the mere possession of the stone should have brought about them. Many gems, namely the Regent and the Sancy, which have decorated the royal crown of France in the past, and the Koh-i-Noor (meaning "mountain of light") which to-day decorated the British crown are known to bring bad luck.

Let us add that these gems, which are quite heavy as far as precious stones are concerned, weigh only a few grams each:

• The Regent weighs 140 carats, or little more than 25 grams (about 0.9 ounce);

• The Sancy: 53 carats, just over 10 grams (about 0.35 ounce);

• The original weight of the famous Koh-i-Noor was 186 (about 37 gramms or 1,3 ounces), but it has been recut several times, thus losing part of its weight.

The Regent can be seen at the Louvre in Paris and the Koh-i-Noor at the Tower of London.

As for the Sancy, after having been sold back and forth several times, it is now believed to be in the possession of an American lady.

Two other gems have been known to greatly exceed these weights:

• The first is a diamond seen in Golconde, India, in the 1500's. The discoverer, J.B. Tavernier, a famous lapidary, estimated it to weigh more than 240 carats (1.7 ounces). Numerous stories have been told about this stone, although they are hardly verifiable.

• The second was named the Cullinham after Sir Thomas Cullinham, first president of the Transvaal Mines Company. This fabulous 3.106 carats (25.7 ounces) was purchased by the government of Transvaal and offered to Edward the Eighth, then King of England, as a birthday present.

Unfortunately, it has been cut and divided into smaller gems of various weights. These were later dispersed through the world, although most of them remain today the property of the Royal Family of England.

Emerald

It is the most beautiful among green gems. Its name is supposed to come from the sanskrit word meaning "stone heart". Very much valued all through Antiquity, it was also supposed to retain numerous powers: it would give richness, develop intelligence and facilitate speech abilities.

Moreover, on a medical level, it was supposed to have a fortifying effect and prevent the falling of hair.

Ruby

A deep-red colored gem. The most beautiful kind is the "pigeon-blood ruby"; because of its rarity, a stone of this quality weighing over 6 carats (1.2 grams) may be much more valuable than a diamond of the same size.

It was believed to dispel evil spirits and to warn against dangers by changing shades.

The Arabs used to prescribe it as remedy for hemorrhages and heart deficiencies. It had to be ground to dust and mixed with a hot potion.

An ancient legend has it that when it was compared to a live piece of coal it was supposed to release an almost supernatural light.

A legend claimed that this gem was taken from the head of certain species of snakes; as they grew old and blind, they would hold it between their jaws to light up their path.

Another claimed that Noah used a single of these stones to light the inside of the Ark during the somber days of the Flood.

Sapphire

Its color is that of blue sky. This is probably why the Hebrews named it "the most beautiful of things". Its shade made it a symbol of deity, and by extension one of justice and loyalty.

Medically speaking, it was supposed to heal eye-ailments and sooth neuralgia and colic. Ground to powder and mixed with milk, it became an effective antidote.

Semiprecious stones

Although more common than the previous ones, these are nevertheless endowed with many qualities.

THE AMETHYST

Probably the most important among semi-precious stones. Its hue goes from a violet color to red, reminding us of grapes and wine, and was thus supposed to dissipate the effects of drunkenness. Moistened with saliva, it would rid the skin of irritations and pimples.
In more recent times, it was used to ornament the Episcopal ring of Bishops as a symbol of wisdom and compassion.

THE TOPAZ

A beautiful saffron-colored stone, it would enhance the charm of anyone whe was to wear it.

This did not prevent it from being a greatly demanded remedy for gout, asthma and even insomnia.

THE OPAL

Regardless cf its nice irridescent shades, this stone has always been said to bring about bad luck.

THE TURQUOISE

Its color varies from blue to green, and it is know to be a very sensitive stone — to the

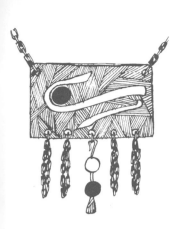

Wire pieces soldered on pendant

point of being ill and withering along with its owner.

On the other hand, it would protect from accidents and dissipate tiredness.

JADE

Although it was not widely used in Europe, the Chinese made it their favorite stone, a symbol of the five cardinal virtues: wisdom, justice, modesty, courage and love for mankind. For this very reason, it was widely used in the carving of statuettes representing gods.

Jade ornaments were also worn as therapy against epilepsy, sciatica and snake bites.

It would be too lengthy to enumerate the qualities of all the other semiprecious stones such as aquamarine, beryl, lapis lazuli, etc. We thus limited ourselves to the most important gems.

We would like to add a few words about other materials which although not classified as stones, occupy an important place in the field of jewelry:

Pearl

Certainly most famous among these is the PEARL, whose origin was long ignored. For the Hindus, it was a rose taken from the waves of the sea... which was true enough. After all, as you well know, pearls are found inside of oysters.

In fact, a pearl results from a reflex of protection on the part of this mollusk against an alien particle of matter brought inside its shell. The oyster produces then a nacreous substance which covers up the extraneous body little by little, thus forming the pearl. The whole process takes years; the larger the pearl, the longer its formation.

It is from this particularity of the oysters that the cultured pearl as developed at the end

of the 14th century by a Japanese man named Mikimotu. The method is as follows: an oyster is taken out of the water and a tiny mother-of-pearl ball is inserted inside the shell. The oyster is then put back in water and left to work on the foreign particle. Several years are necessary to get an average-sized pearl. Moreover, the method is said to fail frequently, some oysters refusing vigorously to produce any pearls.

Amber

Our forefathers were not entirely wrong in conferring powers to this material: when rubbed vigorously, amber stores static electricity and is thus able to attract light bits of paper, feathers, etc.

Moreover, the Greek word for amber was "elektron", from which our word "electricity" was derived.

It is probably because of this particular property that, until recently, babies were made to wear necklaces formed of amber beads as a protection against convulsions.

The origin of amber is peculiar: it is a fossilized resin from a variety of conifers which grew in the areas around the Baltic and North Seas.

Enormous quantities of this sap piled up on the ground and following natural eruptions were driven down under soil and sea, after which the fossilization process began. Amber is still found today in the regions quoted above. Sometimes a perfectly preserved insect is found locked up inside a piece of amber; sap being a very viscous material, it is quite understandable that small animals should get caught in it, only to end as fossils.

Yellow amber should be distinguished from ambergris, which is a soft matter found inside the intestines of certain sperm whales. Although foul-smelling when fresh, it releases an agreable smell as it dries on contact with air.

It is then used in the manufacture of costly perfumes, whereas yellow amber is made into beads, cigarette-holders and numerous other articles.

Coral

It is formed of skeletons of microscopic marine animals assembled together in shape of branches.

Coming from the Greek, its name means "daughter of the sea".

It has been used in the making of jewelry from the earliest times. The Gauls already used it to decorate helmets and shields, while the Romans made amulets and necklaces for new born children from it, as it was reputed to protect from illnesses and accidents.

CONTENTS

Printed in Italy
Poligrafico G. Colombi S.p.A. - Pero (Milano)
N. F 73061